The Works of Christopher

The Works of Christopher

CHRISTOPHER STULL

iUniverse, Inc.
Bloomington

The Works of Christopher

Copyright © 2012 by Christopher Stull.

All rights reserved. No part of this book may be used or reproduced by any means, graphic, electronic, or mechanical, including photocopying, recording, taping or by any information storage retrieval system without the written permission of the publisher except in the case of brief quotations embodied in critical articles and reviews.

iUniverse books may be ordered through booksellers or by contacting:

iUniverse
1663 Liberty Drive
Bloomington, IN 47403
www.iuniverse.com
1-800-Authors (1-800-288-4677)

Because of the dynamic nature of the Internet, any web addresses or links contained in this book may have changed since publication and may no longer be valid. The views expressed in this work are solely those of the author and do not necessarily reflect the views of the publisher, and the publisher hereby disclaims any responsibility for them.

Any people depicted in stock imagery provided by Thinkstock are models, and such images are being used for illustrative purposes only.
Certain stock imagery © Thinkstock.

ISBN: 978-1-4759-5111-0 (sc)
ISBN: 978-1-4759-5112-7 (ebk)

Printed in the United States of America

iUniverse rev. date: 09/14/2012

chapter one

mattrix

Lost in my mind are images of angels god satan were a war broke out at deatsville rd over my soul.

One time when my last name was christopher hoskins I took a peace of papper and sined christopher hoskins as a teenager my soul for a women and a kid! Meanning my soul to have a kid with a women, then one day eric one of my freinds said, "in haul this", with a smile on his face.

My grandparents was so proud of me my basket ball team won a championship with me as a starter my grandfather said, "the starters are the best players." But what I inhauled would be the turnnig point in my life one day. It was inhaulling gasoline, which I told eric I needed help getting off of it!

The reason I liked it was on that I could see god and satan fightting over me. Heres how it all begain one day by my self I said ", satan come to me," he came I was huffing and getting high I saw angels one guy with a chain saw he would fight good angels with swords. I saw an angel standding over all kinds of skulls I called this skull Isaind on top of the hill on my grandfathers land. Look apon the lake can you see what I see a land of great things, adventure, love and crazy things,and

theres a great light and great warriors. This is about my grandfathers land and why my heart ackes for this land lost in my mind!

There allso was a good angel a lion I saw him when I called apon god and the lion chased all the evil angels off.

God even spoke to me told me to breath air and not huff gas but I would keep on so I could see angels. There are many more angels, I saw snakes with parashoots, bubbles phrophecys of my future my arms with all kinds of blood comming from them. I ended up cutting my arms over my exwife who I loved so much and thanked god for her I asked god to hook me up with a women and I meet naomi lost my virginity at 18 years old. I allso saw a green muscle guy with a sword with red dimond shpe eyes, he allso had horns thcompanys

1500

1. heaven-n-hell productions
2. heaven-n-hell records
3. heaven-n-hell poetry
4. heaven-n-hell attourneys
5. heaven-n-hell detectives
6. heaven-n-hell associates
7. heaven-n-hell car lot
8. heaven-n-hell resturants
9. heaven-n-hell pro basketball team
10. heaven-n-hell bars
11. heaven-n-hell construction
12. heaven-n-hell houses
13. heaven-n-hell hospitals
14. heaven-n-hell department stores
15. heaven-n-hell clothes
16. heaven-n-hell furniture
17. heaven-n-hell movies
18. heaven-n-hell robots
19. heaven-n-hell inventions
20. heaven-n-hell agents

21. heaven-n-hell airports
22. heaven-n-hell mansions
23. heaven-n-hell cearal
24. heaven-n-hell soadas
25. heaven-n-hell farms
26. heaven-n-hell cakes
27. heaven-n-hell lakes
28. heaven-n-hell gyms
29. heaven-n-hell beds
30. heaven-n-hell water
31. heaven-n-hell electric
32. heaven-n-hell schools
33. heaven-n-hell shoes
34. heaven-n-hell boots
35. heaven-n-hell pools
36. heaven-n-hell saw
37. heaven-n-hell tools
38. heaven-n-hell apartments
39. heaven-n-hell games
40. heaven-n-hell pool tables
41. heaven-n-hell rings
42. heaven-n-hell air condtioning
43. heaven-n-hell cars
44. heaven-n-hell cartoons
45. heaven-n-hell eggs
46. heaven-n-hell boxers
47. heaven-n-hell cementarys
48. heaven-n-hell blankets
49. heaven-n-hell foods

50. heaven-n-hell caugh drops
51. heaven-n-hell chips
52. heaven-n-hell tables
53. heaven-n-hell ciggaretts
54. heaven-n-hell liquer
55. heaven-n-hell lawn mowers
56. heaven-n-hell lawn service
57. heaven-n-hell motors
58. heaven-n-hell enterprize
59. heaven-n-hell motors
60. heaven-n-hell enterprizes
61. heaven-n-hell books
62. heaven-n-hell novelist
63. heaven-n-hell motel
64. heaven-n-hell heatting and air
65. heaven-n-hell pawn shops
66. heaven-n-hell jewelry
67. heaven-n-hell guns
68. heaven-n-hell giftshop
69. heaven-n-hell gift baskets
70. heaven-n-hell oil
71. heaven-n-hell furniture
72. heaven-n-hell games
73. heaven-n-hell garage doors
74. heaven-n-hell garden supplies
75. heaven-n-hell funeral home
76. heaven-n-hell fruits and vegetables
77. heaven-n-hell fuel
78. heaven-n-hell genarators

79. heaven-n-hell keys
80. heaven-n-hell doors
81. heaven-n-hell tables
82. heaven-n-hell coffee
83. heaven-n-hell salt
84. heaven-n-hell pepper
85. heaven-n-hell sugar
86. heaven-n-hell cream
87. heaven-n-hell cheese
88. heaven-n-hell meat
88. heaven-n-hell eggs
89. heaven-n-hell butter
90. heaven-n-hell baggles
91. heaven-n-hell clinics
92. heaven-n-hell mental associates
93. heaven-n-hell roofing
94. heaven-n-hell pulming
95. heaven-n-hell dump trucks
96. heaven-n-hell bacos
97. heaven-n-hell tractors
98. heaven-n-hell real estate
99. heaven-n-hell trees
100. heaven-n-hell bushes
101. heaven-n-earth productions
102. heaven-n-earth records
103. heaven-n-earth poetry
104. heaven-n-earth attourneys
105. heaven-n-earth detectives
106. heaven-n-earth bars

107. heaven-n-earth car lots
108. heaven-n-earth resturants
109. heaven-n-earth pro football team
110. heaven-n-earth construction
111. heaven-n-earth houses
112. heaven-n-earth hospitals
113. heaven-n-earth department stores
114. heaven and earth clothes
115. heaven and earth furniture
116. heaven and earth movies
117. heaven and earth robots
118. heaven and earth inventions
119. heaven and earth agents
120. heaven and earth airports
121. heaven and earth mansions
122. heaven and earth assioates
123. heaven and earth cearal
124. heaven and earth sodas
125. heaven and earth farms
126. heaven and earth cakes
127. heaven and earth lakes
128. heaven and earth gyms
129. heaven and earth beds
130. heaven and earth water
131. heaven and earth electric
132. heaven and earth schools
133. heaven and earth shoes
134. heaven and earth boots
135. heaven and earth pools

136. heaven and earth saw
137. heaven and earth tools
138. heaven and earth apartments
139. heaven and earth games
140. heaven and earth pool tables
141. heaven and earth rings
142. heaven and earth air conditioning
143. heaven and earth cars
144. heaven and earth cartoons
145. heaven and earth eggs
146. heaven and earth boxers
147. heaven and earth cematarys
148. heaven and earth blankets
149. heaven and earth foods
150. heaven and earth caugh drops
151. heaven and earth chips
152. heaven and earth tables
153. heaven and earth ciggaretts
154. heaven and earth liquer
155. heaven and earth lawn service
156. heaven and earth lawn mowers
157. heaven and earth motors
158. heaven and earth enterprizes
159. heaven and earth books
160. heaven and earth novelist
161. heaven and earth motel
162. heaven and earth heatting and air
163. heaven and earth pawn shops
164. heaven and earth jewelry

165. heaven and earth guns
166. heaven and earth gift shops
167. heaven and earth gift baskets
168. heaven and earth forzen foods
169. heaven and earth funeral homes
170. heaven and earth fruits and vegetables
171. heaven and earth fuel
172. heaven and earth oil
173. heaven and earth furniture
174. heaven and earth games
175. heaven and earth garages
176. heaven and earth garage doors
177. heaven and earth garden supplies
178. heaven and earth generators
179. heaven and earth keys
180. heaven and earth doors
181. heaven and earth tables
182. heaven and earth salt
183. heaven and earth coffee
184. heaven and earth pepper
185. heaven and earth sugar
186. heaven and earth cream
187. heaven and earth cheese
188. heaven and earth meat
189. heaven and earth eggs
190. heaven and earth butter
191. heaven and earth baggles
192. heaven and earth clinics
193. heaven and earth mental associates

194. heaven and earth roofing
195. heaven and earth plumbing
196. heaven and earth dump trucks
197. heaven and earth bacos
198. heaven and earth tractors
199. heaven and earth trees
200. heaven and earth bushes
201. hanze and cetrous productions
202. hanze and cetrous records
203. hanze and cetrous poetry
204. hanze and cetrous attourneys
205. hanze and cetrous detectives
206. hanze and cetrous bars
207. hanze and cetrous car lots
208. hanze and cetrous resturants
209. hanze and cetrous pro hockey team
210. hanze and cetrous construction
211. hanze and cetrous houses
212. hanze and cetrous hospitals
213. hanze and cetrous department stores
214. hanze and cetrous clothes
215. hanze and cetrous furniture
216. hanze and cetrous movies
217. hanze and cetrous robots
218. hanze and cetrous inventions
219. hanze and cetrous agents
220. hanze and cetrous airports
221. hanze and cetrous mansions
222. hanze and cetrous assicates

223. hanze and cetrous ceral
224. hanze and cetrous sodas
225. hanze and cetrous farms
226. hanze and cetrous cakes
227. hanze and cetrous lakes
228. hanze and cetrous gyms
229. hanze and cetrous beds
230. hanze and cetrous water
231. hanze and cetrous electric
232. hanze and cetrous schools
233. hanze and cetrous boots
234. hanze and cetrous pools
235. hanze and cetrous books
236. hanze and cetrous saws
237. hanze and cetrous tools
239. hanze and cetrous apartments
240. hanze and cetrous games
241. hanze and cetrous pool tables
242. hanze and cetrous rings
243. hanze and cetrous air conditioning
244. hanze and cetrous cars
245. hanze and cetrous cartoons
246. hanze and cetrous eggs
247. hanze and cetrous boxers
248. hanze and cetrous cematarys
249. hanze and cetrous blankets
250. hanze and cetrous foods
251. hanze and cetrous caugh drops
252. hanze and cetrous chips

253. hanze and cetrous tables
254. hanze and cetrous ciggaretts
255. hanze and cetrous liquer
255. hanze and cetrous lawn mowers
256. hanze and cetrous lawn service
258. hanze and cetrous motors
259. hanze and cetrous enterprizes
260. hanze and cetrous books
261. hanze and cetrous novelist
262. hanze and cetrous motel
263. hanze and cetrous heatting and air
264. hanze and cetrous pawn shops
265. hanze and cetrous jewelry
266. hanze and cetrous guns
267. hanze and cetrous gift shop
268. hanze and cetrous gift baskets
269. hanze and cetrous funral home
270. hanze and cetrous fuel
271. hanze and cetrous oil
272. hanze and cetrous furniture
273. hanze and cetrous fruits and vegetables
274. hanze and cetrous games
275. hanze and cetrous garages
276. hanze and cetrous garage doors
277. hanze and cetrous garden supplies
278. hanze and cetrous generators
279. hanze and cetrous gardens
280. hanze and cetrous generators
281. hanze and cetrous keys

The Works of Christopher

282. hanze and cetrous doors
283. hanze and cetrous coffee
284. hanze and cetrous salt
285. hanze and cetrous pepper
286. hanze and cetrous sugar
287. hanze and cetrous cream
288. hanze and cetrous cheese
289. hanze and cetrous meat
290. hanze and cetrous eggs
291. hanze and cetrous butter
292. hanze and cetrous baggles
293. hanze and cetrous clinics
294. hanze and cetrous mental associates
295. hanze and cetrous roofing
296. hanze and cetrous plumbing
297. hanze and cetrous dump trucks
298. hanze and cetrous bacos
299. hanze and cetrous tractors
300. hanze and cetrous real estate
301. sun and moon productions
302. sun and moon records
303. sun and moon poetry
304. sun and moon attourneys
305. sun and moon detectives
306. sun and moon associates
307. sun and moon bar
308. sun and moon car lot
309. sun and moon resturants
310. sun and moon pro basketball team

311. sun and moon construction
312. sun and moon houses
313. sun and moon hospitals
314. sun and moon department stores
315. sun and moon clothes
316. sun and moon furniture
317. sun and moon movies
318. sun and moon robots
319. sun and moon inventions
320. sun and moon agents
321. sun and moon airports
322. sun and moon mansions
323. sun and moon cearal
324. sun and moon sodas
325. sun and moon farms
326. sun and moon cakes
327. sun and moon lakes
328. sun and moon gyms
329. sun and moon beds
330. sun and moon water
331. sun and moon electric
332. sun and moon schools
333. sun and moon shoes
334. sun and moon boots
335. sun and moon pools
336. sun and moon saw
337. sun and moon tools
338. sun and moon apartments
339. sun and moon games

340. sun and moon pool tables
341. sun and moon rings
342. sun and moon air conditioning
343. sun and moon cars
344. sun and moon cartoons
345. sun and moon eggs
346. sun and moon boxers
347. sun and moon cementarys
348. sun and moon blankets
349. sun and moon foods
350. sun and moon caugh drops
351. sun and moon chips
352. sun and moon tables
353. sun and moon ciggaretts
354. sun and moon liquer
355. sun and moon lawn mowers
356. sun and moon lawn service
357. sun and moon motors
358. sun and moon enterprizes
359. sun and moon books
360. sun and moon novelist
361. sun and moon motel
362. sun and moon heatting and air
363. sun and moon pawn shops
364. sun and moon jewelry
365. sun and moon guns
366. sun and moon gift shop
367. sun and moon gift baskets
368. sun and moon funeral home

369. sun and moon fruits and vegetables
371. sun and moon fuel
371. sun and moon oil
372. sun and moon furniture
373. sun and moon games
374. sun and moon garages
375. sun and moon garage doors
376. sun and moon garden supplies
377. sun and moon generators
378. sun and moon keys
379. sun and moon doors
380. sun and moon tables
381. sun and moon coffee
382. sun and moon salt
383. sun and moon pepper
384. sun and moon sugar
385. sun and moon cream
386. sun and moon cheese
387. sun and moon meat
388. sun and moon eggs
389. sun and moon butter
390. sun and moon baggales
391. sun and moon clinics
392. sun and moon mentals assocites
394. sun and moon roofing
395. sun and moon plumbing
396. sun and moon dump trucks
397. sun and moon bacos
398. sun and moon tractors

The Works of Christopher

399. sun and moon real estate
400. sun and moon trees
401. earth and mars records
402. earth and mars poetry
403. earth and mars attourneys
404. earth and mars detectives
405. earth and mars associates
406. earth and mars bars
407. earth and mars car lot
408. earth and mars resturants
409. earth and mars probasket ball team
410. earth and mars construction
411. earth and mars houses
412. earth and mars hospitals
413. earth and mars department store
414. earth and mars clothes
415. earth and mars furniture
416. earth and mars robots
417. earth and mars inventions
418. earth and mars agents
419. earth and mars airports
420. earth and mars airports
421. earth and mars mansions
422. earth and mars cearal
423. earth and mars sodas
424. earth and mars farms
425. earth and mars cakes
426. earth and mars lakes
427. earth and mars gyms

17

428. earth and mars beds
429. earth and mars water
430. earth and mars electric
431. earth and mars schools
432. earth and mars shoes
433. earth and mars boots
434. earth and mars pools
435. earth and mars saw
436. earth and mars tools
437. earth and mars apartments
438. earth and mars games
439. earth and mars pool tables
440. earth and mars rings
441. earth and mars air conditioning
442. earth and mars cars
443. earth and mars cartoons
444. earth and mars eggs
445. earth and mars boxers
446. earth and mars cementarys
447. earth and mars blankets
448. earth and mars food
449. earth and mars caugh drops
450. earth and mars chips
451. earth and mars tables
452. earth and mars ciggetts
453. earth and mars liquer
454. earth and mars lawn mowers
455. earth and mars lawn mowers
456. earth and mars lawn service

457. earth and mars motars
458. earth and mars enterprizes
459. earth and mars books
460. earth and mars novelist
461. earth and mars productions
462. earth and mars motel
463. earth and mars heatting and air
464. earth and mars pawn shops
465. earth and mars jewelry
466. earth and mars guns
467. earth and mars gift shops
468. earth and mars gift baskets
469. earth and mars funeral home
470. earth and mars games
471. earth and mars garages
472. earth and mars garage doors
473. earth and mars garden supplies
474. earth and mars generators
475. earth and mars keys
476. earth and mars doors
477. earth and mars tables
478. earth and mars coffee
479. earth and mars salt
480. earth and mars pepper
481. earth and mars sugar
482. earth and mars cream
483. earth and mars cheese
484. earth and mars meat
485. earth and mars eggs

Christopher Stull

486. earth and mars butter
487. earth and mars bagales
488. earth and mars clinics
489. earth and mars mental ass
490. earth and mars rooffing
491. earth and mars pulmbing
492. earth and mars dumptrucks
493. earth and mars bacos
494. earth and mars tractors
495. earth and mars real estate
496. earth and mars trees
497. earth and mars bushes
498. earth and mars computers
499. earth and mars space technonlogy
500. earth and mars space shuttles
501. jupiter and venius productions
502. jupiter and venius records
503. jupiter and venius poetry
504. jupiter and venius attourneys
505. jupiter and venius detectives
506. jupiter and venius associates
507. jupiter and venius bars
508. jupiter and venius car lot
509. jupiter and venius resturants
510. jupiter and venius pro basketball team
511. jupiter and venius construction
512. jupiter and venius houses
513. jupiter and venius hospitals
514. jupiter and venius department stores

515. jupiter and venius clothes
516. jupiter and venius furniture
517. jupiter and venius movies
518. jupiter and venius robots
519. jupiter and venius inventions
520. jupiter and venius agents
521. jupiter and venius airports
522. jupiter and venius mansions
523. jupiter and venius cearal
524. jupiter and venius sodas
525. jupiter and venius farms
526. jupiter and venius cakes
527. jupiter and venius lakes
528. jupiter and venius gyms
529. jupiter and venius beds
530. jupiter and venius water
531. jupiter and venius electric
532. jupiter and venius schools
533. jupiter and venius shoes
534. jupiter and venius boots
535. jupiter and venius pools
536. jupiter and venius saws
537. jupiter and venius tools
538. jupiter and venius apartments
539. jupiter and venius games
540. jupiter and venius pool tables
541. jupiter and venius rings
542. jupiter and venius air conditoning
543. jupiter and venius cars

544. jupiter and venius cartoons
545. jupiter and venius eggs
546. jupiter and venius boxers
547. jupiter and venius cementarys
548. jupiter and venius blankets
549. jupiter and venius foods
560. jupiter and venius cagh drops
561. jupiter and venius chips
562. jupiter and venius tables
563. jupiter andvenius ciggs
564. jupiter and venius liquer
565. jupiter and venius lawn mowers
566. jupiter and venius lawn service
567. jupiter and venius motors
568. jupiter and venius enterprizes
569. jupiter and venius books
570. jupiter and venius novelist
571. jupiter and venius motels
572. jupiter and venius heatting and air
573. jupiter and venius pawn shops
574. jupiter and venius jewelry
575. jupiter and venius guns
576. jupiter and venius gift shops
577. jupiter and venius gift baskets
578. jupiter and venius funerail homes
579. jupiter and venius fruits and vegetables
580. jupiter and venius fuel
582. jupiter and venius oil
583. jupiter and venius furniture

584. jupiter and venius sugar
585. jupiter and venius cream
586. jupiter and venius cheese
587. jupiter and venius meat
588. jupiter and venius eggs
589. jupiter and venius butter
590. jupiter and venius bagales
591. jupiter and venius clinics
592. jupiter and venius mental ass
593. jupiter and venius roffing
594. jupiter and venius pulmbing
595. jupiter and venius dump trucks
596. jupiter and venius bacos
597. jupiter and venius tractors
598. jupiter and venius real estate
599. jupiter and venius trees
600. jupiter and venius bushes
601. uranis and neptune productions
602. uranis and neptune records
603. uranis and neptune poetry
604. uranis and neptune attourneys
605. uranis and neptune detectives
606. uranis and neptune associates
607. uranis and neptune bars
608. uranis and neptune carlot
609. uranis and neptune returants
610. uranis and neptune pro basketball team
611. uranis and neptune construction
612. uranis and neptune houses

613. uranis and neptune hospitals
614. uranis and neptune department stores
615. uranis and neptune clothes
616. uranis and neptune furniture
617. uranis and neptune movies
618. uranis and neptune robots
619. uranis and neptune inventions
620. uranis and neptune agents
621. uranis and neptune airports
622. uranis and neptune mansions
623. uranis and neptune cearal
624. uranis and neptune sodas
625. uranis and neptune farms
626. uranis and neptune cakes
627. uranis and neptune lakes
628. uranis and neptune gyms
629. uranis and neptune beds
630. uranis and neptune water
631. uranis and neptune electric
632. uranis and neptune schools
633. uranis ans neptune shoes
634. uranis and neptune boots
635. uranis and neptune pools
636. uranis and neptune saws
637. uranis and neptune tools
638. uranis and neptune apartments
639. uranis and neptune games
640. uranis and neptune pool tables
641. uranis and neptune rings

641. uranis and neptune air conditioning
643. uranis and neptune cars
644. uranis and neptune cartoons
645. uranis and neptune eggs
646. uranius and neptune boxers
647. uranis and neptune cementarys
648. uranis and neptune blankets
649. uranis and neptune foods
650. uranis and neptune caugh drops
651. uranis and neptune chips
652. uranis and neptune tables
653. uranis and neptune ciggs
654. uranis and neptune liquer
655. uranis and neptune lawn mowers
656. uranis and neptune lawn service
657. uranis aand neptune motars
658. uranis and neptune enterprizes
659. uranis and neptune books
660. uranis and neptune novelist
661. uranis and neptune motel
662. uranis and neptune heatting and air
663. uranis and neptune pawn shops
664. uranis and neptune jewelry
665. uranis and neptune guns
666. uranis and neptune gift shop
667. uranis and neptune gift baskets
668. uranis and neptune funerail homes
669. uranis and neptune fruits and vegtables
670. uranis and neptune fuel

Christopher Stull

671. uranis and neptune oil
672. uranis and neptune furniture
673. uranis and neptune games
674. uranis and neptune garages
675. uranis and neptune garage doors
676. uranis and neptune garden supplies
677. uranis and neptune genarators
678. uranis and neptune keys
679. uranis and neptune doors
680. uranis and neptune tables
681. uranis and neptune coffee
682. uranis and neptune salt
683. uranis and neptune pepper
684. uranis and neptune sugar
685. uranis and neptune cream
686. uranis and neptune cheese
687. uranis and neptune meat
688. uranis and neptune eggs
689. uranis and neptune butter
690. uranis and neptune baggles
691. uranis and neptune clinics
692. uranis and neptune mental associates
693. uranis and neptune roofing
694. uranis and neptune dumptrucks
695. uranis and neptune bacos
696. uranis and neptune tractors
697. uranis and neptune real estate

698. uranis and neptune trees
699. uranis and neptune bushes
700. uranis and neptune pulmbing
701. pluto and satarun productions
702. pluto and satarun records
703. pluto and satarun poetry

book two

aplogies

1. I am sorry for threatting george bush
2. I am sorry for threating george bush
3. I am sorry for threatting george bush.
4. I am sorry for threatting george bush
5. I am sorry for threatting george bush
6. I am sorry for threatting george bush
7. I am sorry for threating george bush
8. I am sorry for threatting george bush
9. I am sorry for threatting george bush
10. I am sorry for threatting george bush
11. I am sorry for threatting george bush
12. I am sorry for threatting george bush
13. I am sorry for threatting george bush
14. I am sorry for threating george bush
15. I am sorry for threatting george bush
16. I am sorry for threatting george bush
17. I am sorry for threatting goerge bush
18. I am sorry for threatting george bush
19. I am sorry for threatting george bush

20. I am sorry for threatting george bush
21. I am sorry for threatting geroge bush
22. I am sorry for threatting george bush
23. I am sorry for threatting george bush
24. I am sorry for threatting george bush
25. I am sorry for threatting george bush
26. I am sorry for threatting george bush
27. I am sorry for threating george bush
28. I am sorry for threatting george bush
29. I am soryy for threatting george bush
30. I am sorry for threating george bush
31. I am sorry for threatting george bush
32. I am sorry for threatting george bush
33. I am sorry for threatting george bush
34. I am sorry for threatting george bush
35. I am sorry for threatting george bush
36. I am sorry for threatting george bush
37. I am sorry for threatting george bush
38. I am sorry for threatting george bush
39. I am sorry for threatting george bush
40. I am sorry for threatting george bush
41. I am sorry for threatting george bush
42. I am sorry for threatting george bush
43. I am sorry for threatting george bush
44. I am sorry for threatting george bush
45. I am sorry for threatting george bush
46. I am sorry for threatting george bush
47. I am sorry for threating george bush
48. I am sorry for threatting george bush

49. I am sorry for threatting george bush
50. I am sorry for threatting george bush
59. I am sorry for threatting george bush
60. I am sorry for threatting george bush
61. I am sorry for threatting george bush
62. I am sorry for hreatting george bush
63. I am sorry for threatting george bush
64. I am sorry for threating george bush
65. I am sorry for threatting george bush
66. I am sorry for threatting george bush
67. I am sorry for threatting george bush
68. I am sorry for threatting george bush
69. I am sorry for threatting george bush
70. I am sorry for threatting george bush
71. I am sorry for threatting george bush
72. I am sorry for threatting george bush
73. I am sorry for threatting george bush
74. I am sorry for threatting george bush
75. I am sorry for threatting george bush
76. I am sorry for threatting george bush
77. I am sorry for threatting george bush
78. I am sorry for threatting george bush
79. I am sorry for threatting george bush
80. I am sorry for threatting george bush
81. I am sorry for threatting george bush
82. I am sorry for threatting george bush
83. I am sorry for threatting george bush
84. I am sorry for threatting georgr bush
85. I am sorry for threatting george bush

85. I am sorry for threatting george bush
86. I am sorry for threatting george bush
87. I am sorry for threatting george bush
88. I am sorry for threatting george bush
89. I am sorry for threatting george bush
90. I am sorry for threatting george bush
91. I am sorry for threatting george bush
92. I am sorry for threatting george bush
93. I am sorry for threatting george bush
94. I am sorry for threatting george bush
95. I am sorry for threatting george bush
96. I am sorry for threatting george bush
97. I am sorry for threatting george bush
98. I am sorry for threatting george bush
99. I am sorry for threatting george bush
100. I am sorry for threatting george bush
101. I am sorry for threatting george bush
102. I am sorry for threatting george bush
103. I am sorry for threatting george bush
104. I am sorry for threatting george bush
105. I am sorry for threatting george bush
106. I am sorry for threatting george bush
107. I am sorry for threatting george bush
108. I am sorry for threatting george bush
109. I am sorry for threatting george bush
110. I am sorry for threatting george bush
111. I am sorry for threatting george bush
112. I am sorry for threatting george bush
113. I am sorry for threatting george bush

114. I am sorry for threatting george bush
115. I am sorry for threatting george bush
116. I am sorry for threatting george bush
117. I am sorry for threatting george bush
118. I am sorry for threatting george bush
119. I am sorry for threatting george bush
120. I am sorry for threatting george bush
121. I am sorry for threatting george bush
122. I am sorry for threatting george bush

the book of songs

1988 album shocker to the system solo album from heaven-n-hell band all done by christopher stull and I dedicate this album to lishia lamar

1. free arms
2. baby
3. shes cocked and loaded
4. train
5. is there a heaven
6. ghost on the hill
7. lost in a dream
8. the blues

songs that didnt make an album songs written by christopher stull and performed by christopher stull

1. a broken heart
2. why does a rose have a thorne
3. i cant go on with out your love

Christopher Stull

song 3
I dedicatted this song to exgril freind kattia

album heavenly thunder.
led vocals naomi and christopher stull
guitar chris stull
bass mike hoskins
key boards shela hoskins

1. is there a heaven
2. lady in the brown dress
3. two angels I dedicated this song to ex wife naomi and lady in the brown dress to
4 i am sorry for losing faith
5. truth or fiction

album 1998 a wounded heart part of album wife and her brother performed with me

1. cadged
2. heavens lost angels
3. lovers till the end
4. two angels
5. lady in the brown dress
6. live to die
7. is there a heaven
8. lost song
9. the night my angel went away

The Works of Christopher

I dedicated this album to my exwife naomi

 songs1998
 city of gold
 one for rock n roll

the other songs are lost lost demo they were performed by christopher stull and mike hoskins

 Is there a heaven without your love
 1999

wrote song in deeper down band heaven or hell mr justice on guitar roach on bass dave on drums

songs

unpleasant dreams lost in a dream heaven or hell 2001 got recording contract for these three at broadway music pro ductions

other songs

 the olive tree
 the worlds desruction
 living life like a sucide
 heaven n hell

songs

 2004
 confused
 one dance

Christopher Stull

 isaw heaven for the first time
 quakes

A place in heaven

 her hairs richer then gold richer then anything known
 it would hurt to see her cry her tears would be like
 rain drops from the sky

 she reminds me of a place in heaven were i would run and hide
 from the darkness in the night a place in heaven
 that wouldnt lie or sprankle rain on me at night

 the moon lights her way threw the night
 giving her light like the sun shinning bright

LAdY IN THE BROWN DRESS

 there she was looking for more then money this time looking
 for love for a lifetime
 lady in the brown dress why you doing this just one kiss
 lady I cant resist just one kiss what a hint

 look at me drankking wiskey looking teanse trying to
 work this out to see you to be with you

christopher

I was born november 3 1977 mothers name is stanette stull fathers name is keith stull my grand mother would baby set me and grew attached to me and said she would take my grandparents to court for custudy of me is what my mom and dad told me. I lived on syvania prp when I was young, at four yeaars old my grandparents went to krogers.

I wantted to go up there so I snuck my uncle mikes car keys out and wrecked his car across the street I hit a chruch sign. My grandfather wipped me good. Then my grandparents moved me to omarkayyam blvd valley station I had these straws that I would blow up like this tar blowed it up in shapes of worlds. At five years old startted school at dixie elementary was a stight a student then they bustted me to mcferren were there were black kids and they were bullys they would start trouble. I joined a football team and was one of the best on the team, the jets. Then my grandpaents and uncle moved me to coxs creek the grils would play frozen kisses with other boys and daniel spauildding said no one wants to play frozen kisses with me i was a bite over weight but i had a grilfreind in louisville at 7 years old that no one new about her name saria and she moved out of valley first but while on a feild trip at coxs creek I asked courtney if I could take her picture I had acrush on her she possed as the queen of eypt and I got her picture

Christopher Stull

my grandparents probally wondered who she was. I was first freinds with david carr.

I would go to his house and play remote control toys with him He came over for one of my birthday.

Then in the fourth grade I meet eric gilkey buy beatting up ronnie in the boys bathroom me and eric became freinds he would stay allnight at my house so would chad sometimes chad said drank vinegar with salt it thins your blood inthe futrure they would have me garagle vinegaer to reduce the swelling in my thorat!

I went to portland and fougt fights gained respect my cousins kenny and jody punked out of fights.

I would work at my uncle jimmy and aunt kathys action and made 15.00 a night iwould stay allnight at debbies and troy would be my best freind we both was over weight I joined a band in portland with jason lewis called heaven and hell I was rythum guitar we played cover songs

www.ingramcontent.com/pod-product-compliance
Lightning Source LLC
Chambersburg PA
CBHW021049180526
45163CB00005B/2357